W9-BRP-683

CONTENTS

INTRODUCTION 5
THE LEFT-HANDED APPROACH 6
A BRIEF HISTORY OF LETTERS 11
STARTING OUT 16
TOOLS AND MATERIALS 16
POSTURE 19
LIGHTING 19
DESK SLANT 20
THE HAND POSITION 21
THE PEN AND PEN NIB POSITION 22
A WORD ABOUT TEACHING CHILDREN 23
MOVEMENT 24
PARTS OF A LETTER 28
SPACING AND ARRANGEMENT 30
EDWARD JOHNSTON'S THREE PRIMARY
CONDITIONS OF WRITING 34
THE MODELS 38
UNCIAL HAND 40
FOUNDATION HAND 44
ITALIC HAND 48
CHANCERY CURSIVE 52
COMPOSITION AND PAGE LAYOUT 56
EXPERIMENTAL AND FREE CALLIGRAPHY 60
EXAMPLES OF STYLE, USE, AND FORM 61
BIBLIOGRAPHY 62
INDEX 63

INTRODUCTION

If you are left-handed and wish to become a worthy penman, then this book is for you. With a little effort, you can learn to letter with the broad-edged pen as well as the right-hander. You will be instructed in the tools needed and how to proceed from a left-hander's point of view. Four model alphabets — Italic, Chancery Cursive, Uncial, and the Foundation Hand — are illustrated. There are no obstacles, nor are there shortcuts. Much, if not all of the information that follows can be useful to the right-handed parent or teacher of a left-hander.

The techniques and suggestions that follow were culled from my experiences in teaching countless students, both left- and right-handed. They will indeed work for you if you are serious about reforming your present writing style and will spend a few hours a week practicing the lessons that make up each of the four model alphabets.

Most likely, your present handwriting was acquired when you were a child and too young to question the instruction you received. Today, with the growing interest in calligraphy, sound and comprehensible instruction for you, the left-handed person, is more important than ever. Unfortunately, too few books and too few classes offer you the same beneficial guidance that is available to the dextral individual.

Learning to write well with the left hand amounts to more than the purchase of an oblique-nib pen; it requires a way of sitting, seeing, and doing. This can be developed by anyone who wants to improve his handwriting and is willing to drop old habits and form new ones.

I sincerely hope the material contained here will guide you and make you personally feel a part of the picture. To learn calligraphy, to put it to use with pride, is to some an enjoyable pastime, a day-to-day source of inspiration for many, and to all who become proficient in the craft, a highly creative and individual means of expression.

THE LEFT-HANDED APPROACH

It is natural to be left-handed. A host of left-handed persons such as Charlemagne, Charlie Chaplin, Leonardo da Vinci, and Pablo Picasso have illumined world history and brightened our lives. The sinistral (from the Latin "sinister" meaning left-hand) comprises approximately 10 per cent of the human population, and since writing has been taught and refined by a dominantly right-handed society, it is surprising that the left-hander has managed as well as he has. The predicament created by this lop-sided fact of life is one where the left-handed person is kept at a disadvantage. He wishes to learn a craft that is invariably taught from the right-handed point of view. Little thought is given to the problems encountered by the person who is wholly inclined to being and remaining left-handed.

It is heartening to find left-handed scissors, rulers, playing cards, and other manual implements in stores. It shows a growing awareness of something that is a little more than a slight inconvenience to the person who must cope with the right-handed way of doing things.

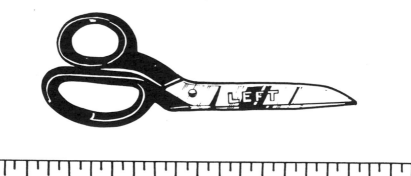

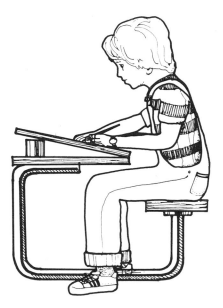

You can, no doubt, recall your first years in the classroom when you were considered a nuisance in lettering sessions and were often dismissed as unteachable by sympathetic but untrained teachers. Children and adults alike want to have graceful and legible handwriting but to try and learn it from the "opposite way around" just does not work. It is an altogether different way of tackling the problem and must be seen from this other point of view.

Time and again I see the beginning calligrapher attempt the basic strokes of italic only to feel he is doomed after the first few feeble curves and dashes. You see, the left-hander feels that the execution of the letter is doubly difficult to make, the pen too unwieldy, and the nib all wrong because he imagines his handicap to be the result of his or her left-handedness. It is easy to see how learning to write for the first time or acquiring a reformed hand with the broad-edged pen is regarded as suspect or even next to impossible for this individual.

When I encounter this plausible but self-defeating attitude, I attempt to convince the person that his disadvantage can be overcome once he accepts three factors:

1. Calligraphy is a skill. This skill involves touch, pressure, hand movement, unity, and that elusive quality we term "beauty." The ability to use these elements in a harmonious way gives rise to legibility which constitutes a major objective of lettering activity.

2. Acquired habits for commercial script writing must be reformed by developing new ones. In time the older style of writing is to be abandoned.

3. The feeling that learning to write beautifully is doubly difficult because you are left-handed compounds the already existing uncertainty that all of us have when embarking on a new discipline.

I will take you through a series of remedial techniques that will enable you, the yearning left-handed penman, to develop a new skill while at the same time carve out an on-going method for self-evaluation and correction of problems as they arise in your writing exercises.

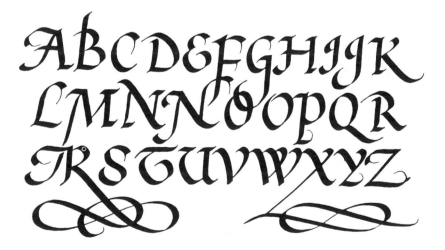

Calligraphy, loosely defined, is the art of beautiful handwriting. This art form, previously thought of as archaic, quaint, and even laborious, is becoming increasingly popular. In part, this is due to calligraphy's disarming beauty and the relative ease with which it can be learned by anyone willing to devote a few hours a week to the assiduous study and practice of letters. The styles of writing illustrated in the following pages will show you the techniques and procedures necessary to master them.

ŋ abcdefghijklmnopqrs tuvwxyz 1234567890

The sinistral, up to now, has had to grope with the pen and its attached chisel-edged nib, hoping to find the best angle and nib relationship to the writing line. Once everything is aligned he is taught to make the sequence of strokes in a "reverse manner" from the right-handed mode. This is likely to create more problems and becomes needlessly vexing. Everything appears to be the "opposite way around." It is like having to think with a built-in mirror. This mental picture is disorienting because the writer must course the line of writing by seeing everything in reverse. The broad-edged nib only makes matters more confusing. For example, when writing in the accepted left to right direction (rather than boustrophedon or "ox-turning" as was characteristic of the writing of the Greeks), the right-handed writer makes the majority of strokes in movements directed primarily away from the body. The left-handed writer makes the majority of strokes in a predominantly pushing movement towards the body.

9

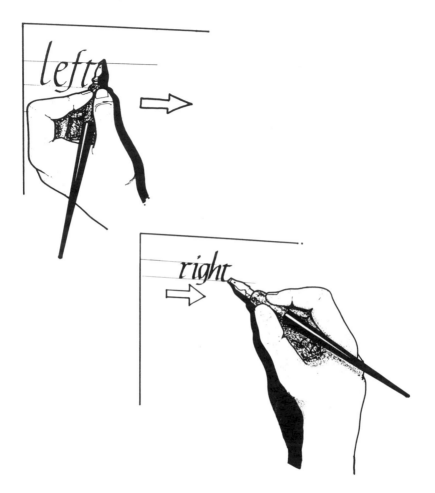

The right-hander pulls the pen across the page from left to right with the writing hand well in advance of the damp ink. To achieve the same results, the left-hander pushes the pen in the same direction while holding the pen in a way that will not smear the freshly written line. This is best accomplished by holding the pen below or in extreme cases, above the line of writing.

Once the left-hander is no longer considered to be a "right-handed writer in reverse," then a technique can be given that is suitable for his express needs.

Roman Alphabet

The Roman alphabet consisted of 23 letters, 13 of which were accepted unchanged from the Greek: A, B, E, H, I, K, M, N, O, T, X, Y, Z. Eight letters were revised: C, D, G, L, P, R, S, V. Two letters were added; F, Q. Three letters were later additions: J, U, W. The Romans painted their letters on stones with a square-edged tool and then incised the letters to create stone-carved or lapidary letters. When most people realize how old the Roman alphabet style is, they are quite surprised because it has a timely, elegant look of great beauty in both proportion and shape. It is with the Roman alphabet that the widely debated serif has its origin owing most likely to the way in which the bristled tool made the beginning and finishing strokes of the letter.

ABCDEFGHIK LMNOPQRST VXYZ

Square Capitals 4th Century

Roman Square Capitals were made with a pen and permitted a more rapid form of writing by the scribe. The obvious impression is one of fluidity with much of the Roman sense of symmetry and proportion.

PRAECEPSREMIGII

Rustic Capitals 5th Century

Rustic Capitals were made with a high, constant pen slant. With the pen as the main writing tool, the scribe wanted to develop a more accelerated style of writing and no longer labored over architecturally precise letter execution. Used by the early Christians, this style is characterized by its attenuated appearance and obvious narrowness.

ENEAS·MAGNAQVEIN
ESTATVRQVEDEOS·ITERV
ISIAMITAIOSHOSTIS·H

Roman Uncials 5th Century

Uncials, meaning "inch high," (a misnomer, for rarely were they drawn to this size) were a further development of cursive writing which reached its pinnacle in Ireland before the end of the Middle Ages. They took their form from square capitals and written capitals. Concurrent with the writing of Roman Uncials was the appearance of a daily writing style whereby letters were hastily joined and gave the appearance of lower case or minuscule letters as opposed to upper case or capital letters called majuscules. Both upper case and lower case are terms derivative of the typographer's lexicon.

NIA ERCO QUAECU

UTFACIANTUOBIS

IOS FACITEEIS ha

National Styles 8th to 10th Century

Most notable of the national variations was the Irish Half-Uncial, which owed its style not to Roman Cursive writing but to the Roman missionaries who came to the Irish coast to further spread Christianity. The letters were written with a horizontal nib and with great speed. In Spain after the conquest of the Visigoths, a style of writing known as Visigothic appeared. With this form, the small letter began to appear frequently and by the 10th century was widespread in use. In France, the Merovingian script soon replaced the Roman cursive.

inʃτauraτιo nulla
nʃlaτι nonaurum

Carolingian Script 10th Century

Carolingian writing was developed under the influence of Emperor Charlemagne and had its beginnings when an Abbot, Alcuin of York, was chosen by Charlemagne as his chief advisor in the great educational revival instituted by that monarch. The Caroline hand had many of the best features of the classical hands of the 6th century and resulted in a Half-Uncial and minuscule of great breadth of treatment and beauty. Its economy of space and legibility was superior to any earlier script in use. In the 10th century the small letter of Carolingian script was in full use.

*Et exsurgens cominatus est uento et dixit mari
tace Et cessauit uentus et facta e tranquillita
ait illis Quid timidi estis necdum habeatis fides
magno amore et dicebant adalterutrum q*

Early Gothic 13th Century

This style was Carolingian in influence and reveals a pointed and more upright profile. The letters are narrower and condensed and begin to point the way to the bookhand known as Textura. Notice that the vigor and freshness of the earlier scripts is noticeably transformed into a printed letter look.

œ ᵱeᵱᵱɪe conœɪɪaṣ
ᴛanᴛ uɪȝɪlanᴛɪbuᵱ.
ouɪbuᵱ auᴛ eᵱᵱɪano

Textura 15th Century

Textura is a Gothic Black Letter, derided by the Italian Humanists. Heavy and dense, Textura is reminiscent of the early Roman style and lacks the radiant full form so typical of the period. The pointed or vaulted arch in Gothic architecture can be seen in the sharp angulation of the black letter which makes use of straight lines rather than curved ones. Early book printing with movable type took its form from the Gothic Black Letter because it was in direct imitation of the then prevailing handwriting.

gebieten hin ze frankenfur
füllen gebieten dem bistof
megentz bi dem panne·vnd

Humanistic 15th Century

The Gothic letter never really took hold in Italy; therefore, there was much interest in the cursive writing of the Humanists, who revived the literature of the classical period. They used as their model the Carolingian hand but evolved an altogether more clear and rhythmic style.

igitur habet poteſt

Humanistic Cursive 15th to 16th Century

Papal scribes in the Vatican were responsible for this elegant form of italic writing which serves as the basis for the Chancery Cursive contained in this book. Chancery Cursive is characterized by a compressed, elliptical shape and slight slant to the right angle. Arrighi, Tagliente, Palatino, and Lucas are just a few of the significant writing masters of the 1500s. In time, the services of the scribe declined owing to the rapid and widespread use of printing made possible by movable type and the printing press.

ribus hris annotandas uoceſſ
rium · Quod partim pro uolun
partim uſu proprio : et obſerua
nanq · apud ueteres · cum usus

STARTING OUT

The availability of calligraphy and lettering materials has never been greater than it is today. You have a wide choice of pens, papers, inks, carpenter's pencils, and pre-ruled guide sheets from which to choose. These materials are inexpensive and accessible. The entire activity is conveniently portable because so little material is required and practicing can be carried out in quiet areas when a few moments or an hour or two can be set aside to study the lesson at hand.

Many calligraphy teachers have devised methods of instruction that they consider to be the best, however there exist many ways in which to teach any given writing model. The methods and materials set forth here are designed to provide you with a style of handwriting and lettering that can be a strong personal message, but its message is based upon widely accepted qualities proper to letters and their correct use. The introduction to the necessary tools, materials, and their characteristics is based upon my personal experience and the experiences of my students.

TOOLS AND MATERIALS
Pens

You will need a Platignum fountain pen with an italic broad nib. Initially, the nib you will require is a Platignum Italic B2 Left Oblique. The nib is sold separately or may be purchased as part of an Italic set. The set includes 5 interchangeable nibs and a fountain pen. I recommend this pen because the ink is always ready to flow and the whole unit is easy to maintain. The Platignum line is available in art, stationery, and most campus book stores.

The Osmiroid Fountain Pen may also be used. You may need to prime the pen frequently by pushing down hard on the nib to begin ink flow. This is one of the drawbacks to the pen. However, if you use a thin fountain pen ink such as Pelikan 4001, you will have better results. Purchase the left-hand medium 30 degree oblique nib. Add to the fountain pen an additional purchase of a Higgins Speedball C-0 Left and C-2 Left nib with the appropriate pen nib holder. These are

known as dip pens and will be used to make large letters, titles, and headlines. Note: For reasons I will cover later, you may want to try the equivalent right-handed nibs after you have experimented and worked with these above items.

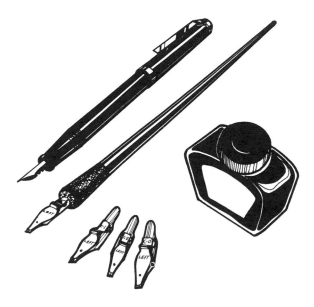

Paper
Regardless of which paper you choose, there are several factors you should consider. These are: surface, cost, availability, and use.

Surface
When using the edged pen on the paper, the thin and thick strokes must be sharp with no ragged edges or unnecessary friction caused by a cold press or fibrous finish to the paper's surface. Try to find a smooth paper which permits use of either side. For the initial practice efforts a slightly transparent paper is necessary so that you can place it over your guideline sheet.

Cost

Because of the inordinate amount of paper you will be using to practice the exercises, it is important that you purchase relatively inexpensive paper. This eliminates the pervasive feeling that one must use paper sparingly. Use as much as is necessary to bring your writing to a satisfactory level.

Availability

Writing papers are available in categories such as stationery, printing, bond, or calligraphy paper. Calligraphy paper, usually sold in tablet form, is receptive to ink and has a good writing surface. This paper may also be used for other pen and ink work and can be purchased with or without printed guidelines. Lightweight duplicator and photocopy machine papers are also useful. For practice work try to locate Zellerbach Thor Onionskin paper in either white or canary yellow. There are 250 sheets in each inexpensive package.

Use

For correspondence and finished work consider a paper that has a laid finish and a watermark. These features indicate a fine paper, which is more personal. Strathmore and Crane writing papers and matching envelopes come in a variety of finishes and colors and can be ordered from your local stationer.

Calligraphy to be used as camera-ready art should be executed on a smooth white paper or board such as Strathmore one-ply or two-ply plate finish paper. Kid finish paper can be used when a rougher line is desired. Other very good papers such as ledger, ermine, and parchment papers should also be tried in order to give you a well-rounded introduction to various writing surfaces.

Inks

Inks to be used in fountain pens should be free-flowing and water soluable. The following inks are recommended because they are not likely to clog the pen during ordinary use. Pelikan 4001 Black fountain pen ink is ideal. It has just the right amount of density and flows in all types of fountain pens. Parker Super Quink Washable black is great for children's use. The British made Stephens fountain pen ink and Calligraph

ink work nicely too. The Pelikan 4001 series is also available in several colors. For permanent black ink to be used with dip pens, I have found Higgins Black Magic to be useful on film, paper, and cloth. Pelikan Fount India ink or Higgins Engrossing ink work as well but on paper only. Do not use waterproof India inks in fountain pens.

Miscellaneous Materials

You will need to rule out a guide sheet to match your pen nib. By doing so you will maintain the correct relationship between letter and surrounding space to avoid a heavy look. A 12-inch ruler and some smooth card stock or smooth poster board cut to size will do the job. Measure the lines and mark according to the respective guideline page illustrated with each model alphabet.

A lint free handkerchief is used to blot the ink and clean the nib after the pen has been filled.

POSTURE

Your seated position should be comfortable. No two scribes sit exactly the same way. The important thing to remember is to minimize tension anywhere in the body whether it be hand, neck, arm, or back. The shoulders and front of the body should be parallel to the desk edge, with the mid-section about 4 inches away from the table's edge. The left forearm should rest flat on the table.

LIGHTING

Available light from a window is the best source of illumination. Artificial light from a lamp is to be placed to the right of the left-handed person.

DESK SLANT

A desk slant of 45 degrees or slightly less will help to reduce fatigue as you practice each exercise. An inclined writing surface will also help you maintain a correct perspective of the letters as they are drawn. The head should be kept at a respectable distance from the sloped surface. Insert a coffee can between the table top and a smooth writing board to create a temporary make-shift writing table.

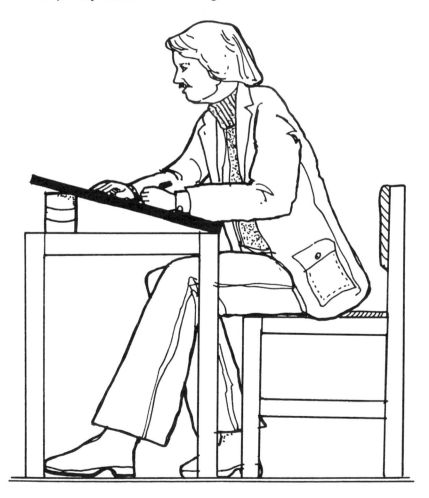

THE HAND POSITION

The position of the hand is largely governed by whether the writing is to be done from above or below the writing line. Once a comfortable choice has been made, the following should be attempted. The pivotal action of arm and hand movement across the writing surface should take place in the shoulder while the forearm moves outward. The elbow is not to be held so close to the side of the body that it touches. The forearm and hand follows the writing as letters are made in a left to right manner. The edge of the hand rests on the writing surface. Too much hand contact with the writing surface interferes with movement and can retard speed when it is desirable at a later time. There is also likely to be an increased possibility of smearing the wet ink.

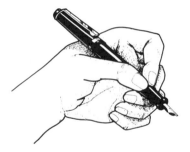

For the correct pen hold, the fourth (little) finger touches the third finger and both are neatly tucked into the palm. Do not write with either of these fingers extended. They only get in the way. The pen shaft is lightly held between the thumb and first finger, and rests on the side of the knuckle of the first phalanx of the second finger. This permits a very vital movement: As the letters are drawn either inward or outward the finger can be extended in a relaxed manner, carrying the pen with it. This is particularly helpful when tall letters are made. The additional "reach" helps to keep the line consistent in width in the downward stroke as in the case of an ascending, descending, or capital letter.

Slight variations of this hold should be attempted if it is altogether too restrictive. This is often the case with an individual who has written for years with a noticeably incorrect penhold such as the "pushed finger" or when the thumb is too advanced. I have also encountered writers who hold the shaft of the pen or pencil between the second and third finger, this is another grievous fault. If this is how you hold a pen, try to reform your hold if at all possible. It is not overly difficult and when the correct hold is coupled with a new way of making letters, it can be a cheerful indulgence rather than an odious grind. Your writing will show results within a few hours of practice. Make the transition slowly but do so with a certain and definite desire to improve your handwriting and in time, a new habit will replace the older one.

Correctly proportioned letters, whether they be Italic or Foundation in style, are best made with finger movements that are carefully co-ordinated with hand movements. Together, in healthy unison, the grasp is to be a light one and one where the hand does not rely on a firm and weighty contact with the sloped surface.

THE PEN AND PEN NIB POSITION

The shaft of the pen is held at a 45-degree angle to the writing surface regardless of whether the table is flat or sloped. As the table tilts, so must the pen in a likewise manner. This will keep the ink flowing, reduce unwanted drag, and serve to reduce tension in the grasp.

For italic writing, the edge of the nib is also to be kept at a 45-degree angle to the writing line known as the base line. In order to keep the up-stroke thin and the downstroke thick it is necessary to adhere to this angle. This never-changing relationship between nib and writing line is most important in Italic and Chancery Cursive writing. Pen "tricks" and twists will be so noted in other styles but should only be attempted when the basis for this rule is understood. The accepted way to check if nib position is correct is to make a written cross. In so doing, both vertical and horizontal lines

should be equal in width. If one stroke is larger than the other, then the nib angle is askew. Also attempt to make a small x. If the nib angle is correct, then the top right to bottom left stroke will be the thinnest.

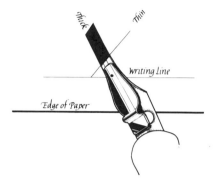

A WORD ABOUT TEACHING CHILDREN

If you teach handwriting to children, it is wise to stress the importance of posture, illumination, and comfort. Simply stated, the child is to plant both feet on the floor, sit straight and naturally so, with shoulders and the forefront of the body parallel to the desk's edge. Optimal distance between the writing surface and head is to be 12 inches to 14 inches. A hunched or slouched posture is to be avoided. If the head is turned sideways to the writing surface, one eye may dominate. Peripheral vision is maintained when the head faces the work straight on. Writing sessions should not exceed 30 minutes for young children. Lighting should be even with no surface glare caused by lamps that are placed too close to the work area. Glossy paper is not to be used. The left-handed child presents no special exception, but his movements should be closely observed so that you can correct potential problems which may cause strain, headache, or contribute to a curved spine while in the seated writing position.

It is surprising how just a few minutes of daily observation by a teacher or parent can help to prevent a child from having posture and writing difficulties in later life.

MOVEMENT

Once the model alphabets have been learned and good results are obtained, there is a gradual reduction of tension in the hand and other instrumental muscles throughout the body. The movement of the pen should be light, graceful, and above all, contribute to a legible style.

The alphabet we use is composed of visual phonetic symbols, and when they are neatly and clearly rendered, communication is hastened. Good writing is rhythmical and patterned and each stroke is to be seen as the path of the moving line. Therefore, particular care should be given to the nuances of each letter to bring out the full character of each symbol.

POSITIONS FOR CURSIVE WRITING

There are two positions for italic handwriting that work well for left-handed calligraphers; one of them should be comfortable for you. Be sure to use the left-oblique nib.

Position I

With your pen below the writing line, try to maintain a comfortable feeling in your wrist. Move your elbow close to but not touching your side. Angle the pen so that it points to the left shoulder or just slightly inwards, more to the center. Tilt the paper so that the writing line is higher on the left. There is no fixed position that will work for everyone. Experiment. Continue to tilt the paper until a satisfactory angle is found. This may result in quite an extreme angle but for some this works best. The right hand moves the paper up and down as each line of writing is completed. The bottom right-hand corner of the paper will point towards the body. Material to be copied or studied is kept to the left of the writing paper.

Position 2

Following the above position, move your elbow away from your left side to provide maximum freedom of movement. This also means that the writing line must be tilted to a greater slant to be in harmony with the position of the elbow. Keep your hand below the writing line.

In every group of left-handed individuals, I invariably find a small minority who write from an above-the-line position. This creates a hooked angle where the wrist and hand curl over in direct imitation of the right-hander's hand position. This position usually develops in early training when a student is taught to imitate the angle of the right-hander's pen shaft rather than being taught to write below the line which is the usual way it is done. Therefore, in effect, the pen has now been moved 180 degrees clock wise from the position of the right-hander. This does not take into consideration that the right-handed scribe also holds his pen at a varying angle which would increase or decrease the degree of the writing position as measured by the left-handed hold. When this position is used, it obviates the need for the oblique nib. Add to this the need to push the pen rather than pull and pull when others usually push.

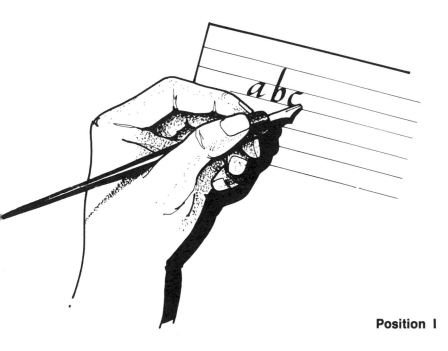

Position I

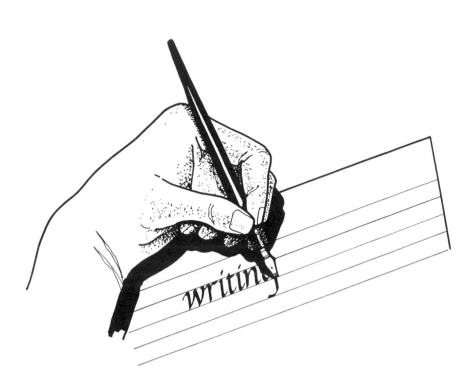

Position 2

Left-handers often write with a backslope. In cursive script this occurs because of the particular angle of the pen in either below- or above-the-line writing. The hand can make an elliptical shape more easily than a round one. For the left-hander, the backsloping ellipse presents less difficulty. For the right-handed writer, the forward slanting ellipse is easier to make. In both cases, the ellipse is the natural shape because the fingers need not pull the pen unnaturally beneath the hand to form the outer curve of a true circle. Rather, it is simpler, in many examples of writing, to make a fully cursive letter in a two-stroke manner thereby gaining more control as the line is made by pulling instead of pushing the tool upwards. If the nib is pressed down too hard, the knife-edge of the nib

can easily dig into the paper and cause spattering to say nothing of a poorly formed letter. Try this yourself by drawing the letter o. A better o, for the beginner at least, can be drawn with two strokes rather than one stroke.

The back-handed slope for the left-hander can usually be corrected by following two recommendations:

1. Pay particularly close attention to the model and angle the pen and nib so the correct swelling of the letter line occurs precisely where it should. By all means trace, trace, trace. Then copy until your writing resembles the model.

2. Experiment by making letters — especially in the italic mode — by moving the elbow away from the body, rather than keeping it too stiffly placed and tucked in. If letters are made with the elbow moving outwards in small degrees, then a comfortable and relaxed position will soon be found. It is imperative that you give some time to this matter as the solution does not always quickly present itself.

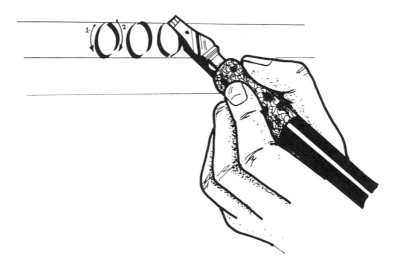

PARTS OF A LETTER

Letters and the space they occupy are made up of parts. Each part has a particular name to make the discussion of letters easier to understand. You would do well to familiarize yourself with the vocabulary.

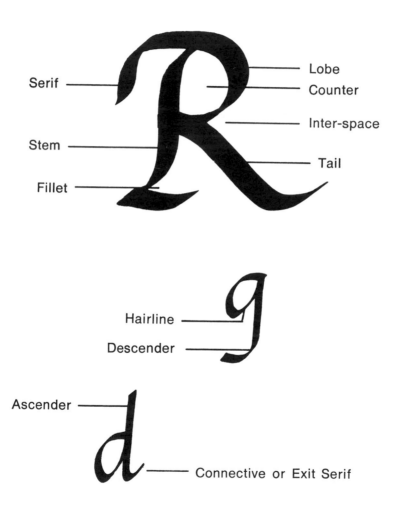

Guidelines

The writing guidelines are noted as such (from top to bottom): Ascender Line, Capital Line, Waist Line, Base Line, Descender Line. These guidelines must be used to keep proportions accurate until such time the calligrapher has memorized and is able to draw the letters without benefit of the lines. The size of capitals used in this book can vary, however most letters within the respective capital family remain constant in height. Capitals require only two guidelines: the Base Line and the Capital Line.

Small letters require the benefit of all four writing guidelines to accommodate not only the body letter, such as the letters a, c, e, etc., but ascending and descending letters as well, such as b, d, f, g, h, j, etc.

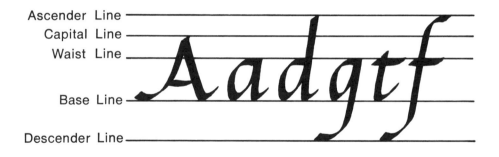

Ascender Line
Capital Line
Waist Line
Base Line
Descender Line

SPACING AND ARRANGEMENT

It is significant that the beautifully written manuscripts of the Middle Ages and the early printed books of Gutenberg, The Aldine Press, Giambattista Bodoni, and John Baskerville all exhibit the even tone that comes from fine spacing and proportion, the results of the correct relationship between text and page. The ability to recognize the importance of spacing and arrangement is a matter of discrimination and to discriminate suggests a definite standard of comparison as a basis of judgement. By tracing and copying works of admitted excellence, you can familiarize yourself with the finer points of letter and word arrangement.

The general objective in calligraphy is to create a panel of even-toned text and to arrange the text on the page with pleasing margins which serve to frame the work. Even tone can result from the equal distribution of black and white (lettering and paper) and the overall composition as it is laid out on the page. The spacing of letters in a word, words in a line, and how the lines are used in the overall context of the piece concern us here.

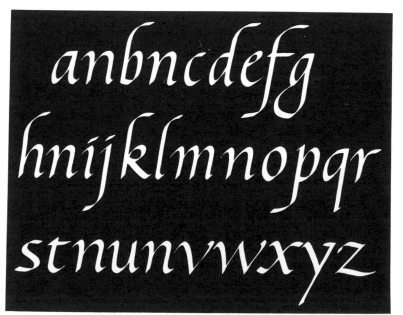

Letters

The interior spaces of letters should be consistently even. Letters such as o and a may appear too heavy as a result of the imbalance between the letter shape and the space it encloses. The following guidelines may help the letterer space his work more evenly.

Two round or cursive letters are to be spaced close to one another. Example: good. A letter made with a vertical stroke next to a round letter should be given a little more space between the two. Example: pond. Where two vertical letters are used next to one another, there must be enough space left between them to balance the wide interspaces of the round or cursive letter. Example: hill. Although no precise formula exists for spacing, it can be optically developed by a close examination of the letter, its surrounding space, and the overall pattern of the writing as it appears on the page.

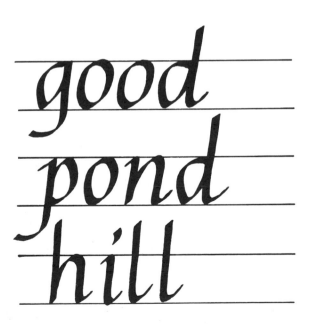

Words

Words are composed of one or more letters and should appear as units on the page. As the eye skims over the words, one is not to be made conscious of the narrow or wide spaces between the units of the line of writing creating what are known as "rivers" of white space on the page. The rule of thumb here is to leave the equivalent of the letter o between each word. Initially, you may have to draw an imaginary o between the words until the effect is felt.

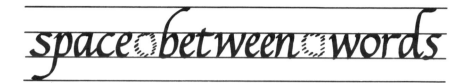

Lines

The space between the guidelines is largely governed by the height of the letters. Ascenders and descenders must not overlap one another or become entangled. If the body letter a is chosen as the basic unit of measurement, then be sure that a division of space exists between the bottom-most part of the descender and the upper-most part of the ascender on the following line. Ideally, they should not touch. When all capital letters are used, space must also be permitted between the capital line and the base line above it.

Page

The composition of letters on a page, invitation, card, announcement, poster, or manuscript double-page layout is more a matter of conscious choice than agreed upon rules. Good results can be obtained by not overcrowding the page in formal writing. A page that has one-half or less devoted to text is pleasing to the eye and more likely to be legible. The size of the letter you use and the model you employ can be adjusted to fit these spatial considerations.

EDWARD JOHNSTON'S THREE PRIMARY CONDITIONS OF WRITING

Edward Johnston (1872-1944) single-handedly revived calligraphy and is largely responsible for ushering it into the 20th century. Johnston felt that there are three primary conditions that determine the special character of letters made with the broad-edged pen. They are the WEIGHT of the stroke, the ANGLE or position of the nib's edge, and the FORM of the letter. The left-hander must develop control and maintain a careful watch when these three conditions are followed. They are important because:

1. By direct manipulation of the pen and nib to follow weight, angle, and form, the left-handed scribe will make better letters and learn to adopt the mental attitude and the necessary physical displacement of body and tool to bring about the desired form.
2. For writing to appear consistent in design and form, regardless of which style is used, these three conditions must be constant.

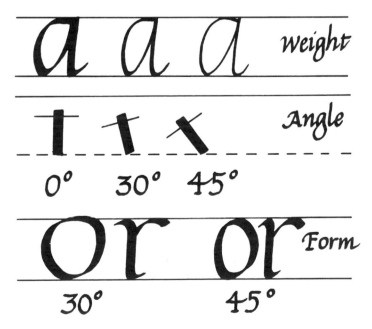

Weight

The width of the nib's edge, which may vary from fine left oblique to broad left oblique for the left-handed, determines the "weight" of the letter in relation to the letter's height. A broad nib used to make letters within thinly spaced guidelines produces a heavy letter. Conversely, a finer nib within the same space produces a letter which is "lighter" in appearance. This can be better understood if the lines of the letter can be compared to the "mass" of the line. A heavy line suggests greater visual mass which is the hallmark of Gothic Black Letter writing and some of the later Medieval bookhands. Experiment with three different nibs of varying width. Make the letter o three times, each time with a different nib, on the same Base Line. Notice how the counter of the letter changes shape in each example. As your letter-making ability increases, consider this as an important variable when drawing Uncial, the Foundation or Formal style, and Gothic Black Letters. In Italic, the pen width determines the size of the letter and should remain constant throughout.

Angle

The angle of the nib in relation to the line of writing is also a contributing factor in writing. As mentioned earlier, Italic writing calls for a constant nib angle of 45 degrees to the writing line. In other styles the angle of the nib might be set at 0 degrees to the writing line. This can be the case when making Uncials, Irish Half-Uncials, or Versals which are all characterized by round open qualities compared to the narrow pointed style of the later Gothic period.

Uncials may also be rendered with a 30-degree pen-nib slant giving a slightly different appearance. It too, must remain constant throughout the writing exercise.

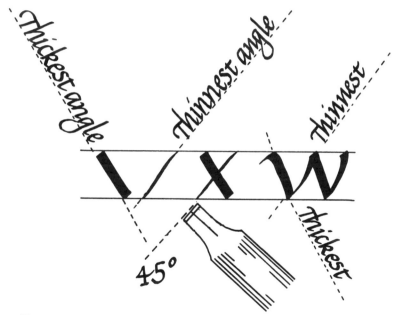

Form

The form of the letter is the letter's characteristic shape. The form is regulated by the position of the nib, the width of the nib, and the way in which the letter is planned and built.

If we return to the letter o as our example, we can render it in a round, full Roman style with an upright position, or make the same letter in a compressed, oval, and slanted fashion known as Italic. In between the Roman letter style and the later Italic letter style rest many different families of letters of which Rustica, Uncial, Half-Uncial, Carolingian, Versals, Lombardic, and Gothic Black Letter, are but a few.

Many experimental letters and calligraphic forms of writing can be invented by orchestrating weight, angle, and form. These elements can be rigidly fixed and studied from numerous extant manuscripts falling within agreed upon groups or families. However, dogged adherence to these is not always required. A good penman can modify or create new letter shapes to be used in a variety of ways to suit his mood and work.

A more detailed account of Johnston's observations is beautifully assembled in his posthumous work, **Formal Penmanship and Other Papers,** edited by Heather Child. For all calligraphers interested in grasping the finer points of letter construction, this book is a must.

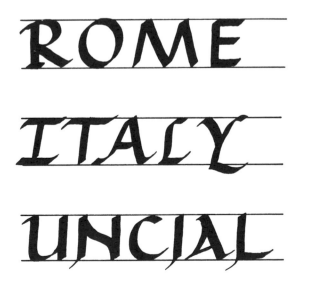

THE MODELS

Before attempting to copy any of the following exercises, a few words about relaxing are in order.

No calligrapher can abruptly turn from frenetic activity and be expected to sit down and make beautiful letters without first relaxing the entire body, especially the arm, hand, and fingers. Mental excitement can also interfere with the concentration so necessary to the study and practice of lettering. A quiet room, good lighting, and no distractions are going to be your best rules to follow. Personally, I squeeze a tennis ball for a few minutes to loosen up and make supple the muscles of the hand and fingers. It's no contest, but the slow expansion and contraction help my fingers to relax and to better perform the manual exercises that lie ahead.

Spend a few minutes reading over the notes on the model page before you attempt the basic strokes. This will familiarize you with the hand and will answer many questions that might arise when you are in the midst of a letter, which is not the best time to have questions arise.

Keep a clean, thin sheet of bond paper, called a slip sheet, underneath your hand as you write. This will keep oil from the skin off the writing page. If your hands tend to perspire, then the slip sheet is all the more important.

Practice strokes are a must. Spend no less than 15 minutes on the material that is designed to help you align arm, pen, and nib to the correct writing angle. The left-hander must especially coordinate his performance.

Write slowly. Savor the line, its angle, and the undulating trail the ink leaves as each part of the letter is drawn. Hurrying and skimming over the material will only prolong the lesson in the long run.

The italic hands are designed to be used in place of the running handwriting style. A rapid cursive form of writing will come with time. The Uncial and Foundation letters are to be thought of as bookhands and are not to be joined as in italic handwriting.

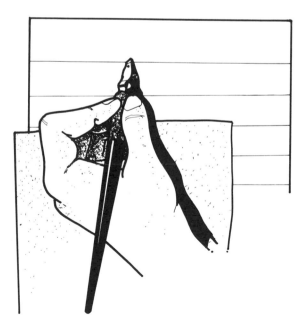

UNCIAL HAND

The hands in current use at the beginning of Christianity are shown by the simplest distinctive signs of the written form. They are especially suited, therefore, as practice hands, because they have developed from a constant position of the pen. The Uncial hand is a rounded hand as compared with the previous squared hand typical of Roman capitals and the pen-written Quadrata capitals of the 2nd to 5th centuries. Uncial is a typical penman's hand. Its form is curvilinear rather than rectilinear. This is a very graceful and harmonious letter and the particular version used here is composed solely of capital letters. Small letters, influenced by the uncial letter, can be found in the hand known as Half-Uncial. In the later hand, letters emerge in a lower case style and usually are linked or joined.

VITAE

SUMMA

BREVIS

ROMANISCH

UNCIAL

the shattered water made a misty din.
great waves looked over others coming in.

and thought of doing something to the shore
that water never did to land before.

URKUNDEN

The model drawn here requires a pen nib angle of 30 degrees from the writing line (base line). For the left-handed, the pen nib is placed on top of the practice stroke and drawn downwards toward the body. This is the pull stroke for the below-the-line writer. The push stroke occurs with the cursive parts of letters and are to be made slowly to feel the gliding motion of the pen and to give correct form to the letter. Note the axis of the letter o. The thinnest hairlines are at 11:00 and 5:00. The letters are full and round. If serifs are used, they are to be made by overlapping, at an angle, the top of the letter as shown. Letter height is 4½ pen widths. Letters are vertical. No slant is used.

If you use the left-oblique nib, then the elbow is to be comfortably placed approximately 6 to 8 inches from the left side.

UNCIAL *B-2 Nib*

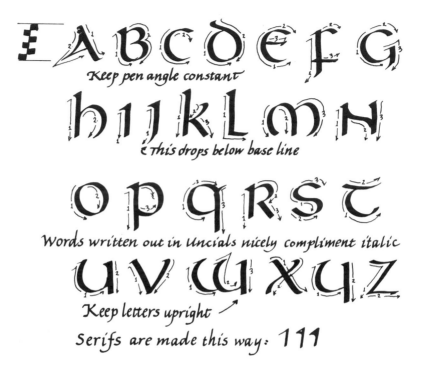

Keep pen angle constant

ɛ This drops below base line

Words written out in Uncials nicely compliment italic

Keep letters upright

Serifs are made this way: 111

A B B C D D E F

F G H I J J K K K

L M M M M N N

N O P P Q R R

S T T U U U U V

W W W U X Y Z +

FOUNDATION HAND

The Foundation Hand was designed by Edward Johnston and is based on a 10th century English round hand. It is a kind of writing that requires the use of the broad-nibbed pen. The formal hand, as it is sometimes referred to, receives much of its influence from Roman capitals and Roman small letters. The letters are made upright and full. The body letter, a for example, is 4½ pen widths in height. The angle of the nib is to be kept constant at 30 degrees. The left-hander should use the most left-oblique nib and tilt the paper until a comfortable arrangement is achieved. The diagonal edge of the oblique nib must make full contact with the paper. There may be a tendency to favor the shoulder of the nib until the full contact position is felt.

Practice making vertical strokes at 90 degrees to the writing line. Slowly tilt the paper until the vertical line is made effortlessly. In spacing, the width of the "-" is used to separate words. Careless joins as a result of unintentional overlapping are to be avoided. These impair legibility and can take on the appearance of ligatures, which are two or more letters that are linked together to conserve space.

For the capital letters, relative proportions are as follows: Round letters take up the space of a drawn square: O, Q, D, C, G. Rectangular letters occupy approximately ¾ of the square: N, T, U, X, Y, Z, H, A, V. Wide letters: M is contained within the square, W exceeds the left and right boundary of the square. Narrow letters are approximately ½ the width of the square: B, R, P, J, S, K, F, L, E, and J. The letter I remains and is self-explanatory.

The Foundation
Hand was designed
by Edward Johnston

round & formal

FOUNDATION HAND B-4 Nib

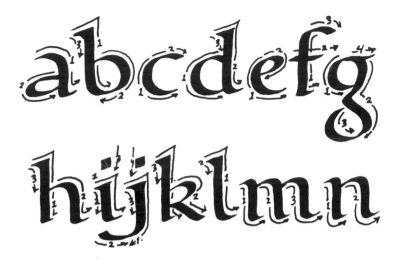

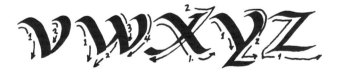

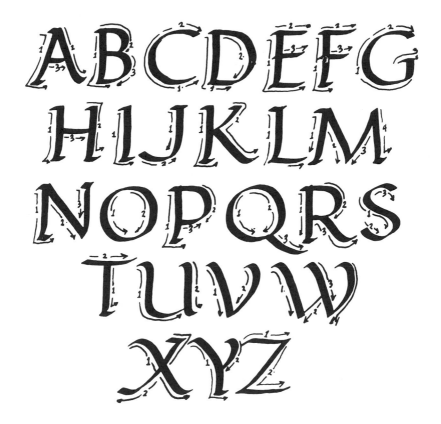

ABCDEFG
HIJKLM
NOPQRS
TUVW
XYZ

1234567890

ITALIC HAND

The 15th century in Italy during the Italian Renaissance is regarded as the finest period in the history of handwriting. Florentine scholars discovered old manuscripts written in Carolingian minuscules of earlier centuries and these were the splendid round letters from which this cursive handwriting was developed. The hand was eventually adopted for diplomatic use in the Chanceries at Venice and Rome and underwent some changes to make it adaptable to the scribes' speed writing.

The nib is kept at a 45-degree angle to the writing line at all times. Gradations of strokes are achieved by pushing on the upstroke and pulling on the downstroke with the left-oblique nib. In essence a pyramid is formed. Height is 5 pen widths for the body letter. Ascending and descending letters are 9 to 10 pen widths in height. Capital letters average 7½ pen widths in height. The letters are compressed and elliptical in shape and slope to the right by 5 to 7 degrees. The basic strokes are to be copied, even traced, to develop a feeling for writing on this particular slant with the broad-edged nib.

If you are an above-the-line writer and you find it too difficult to switch to a below-the-line position, then move the elbow about 9 or 10 inches away from the body to lessen the angle of the wrist and the subsequent penhold. A right-hander's nib that is cut straight across may make it easier for you to form the letters. It will be necessary to raise the wrist a bit to prevent smearing of the ink. There exists a natural concavity where the hand joins the wrist. Angle the paper so the writing line trails underneath this concavity to see if it is to your liking. All a bit exotic, but for some, I have seen this work well.

Practice Strokes

X X X X X X X X X X X X

+ + + + + + + + + + +

//// //// //// //// //// //// //// //// /

ılıl ılıl ılıl ılıl ılıl ılıl ılıl ılıl ılıl ıl

\\\\ \\\\ \\\\ \\\\ \\\\ \\\\ \\\\ \\\\ \\

(((()))) (((()))) (((()))) (())

m m m m m m m m m m m

w w w w w w w w w w w w

≡ ≡ ≡ ≡ ≡ ≡ ≡ ≡ ≡ ≡

ηηηη llll ηηηη llll ηηηη llll

O O O O O O O O O O

ITALIC HAND *B-4 Nib.*

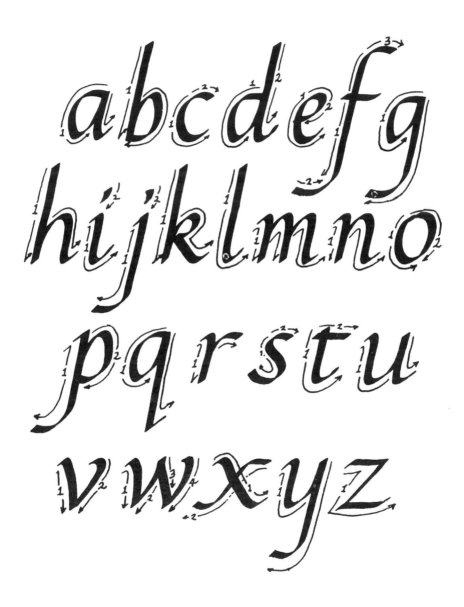

The left-hander should attempt each letter in the stroke sequence illustrated. Maintain a 45° nib angle to the base line.

B-3 Nib

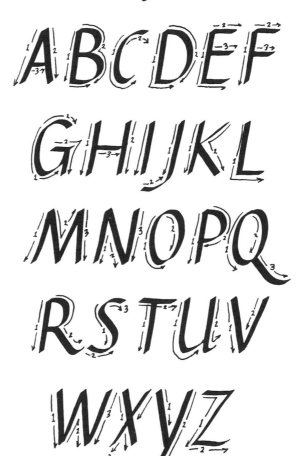

CHANCERY CURSIVE

Whereas italic writing was originally based on the Caroline hand, the first uses of it during the 15th century reveals the letters to be slightly compressed, rather full, and given the term "antiqua" because it was believed to be the style of the ancients. Humanistic cursive is the foundation name. The Chancery style refers to the calligraphic tradition that emerged in Venice and Rome at the end of the 15th century. The Vatican Scribe, Ludovico Arrighi, in his book Operina, advocates a slightly taller version of the earlier italic form and shows both ascenders and descenders to bend to the right and left, respectively. The Cancellarescha writing in apostolic briefs of the early 1500s is marked by expressive, quick, and rhythmic movements. The letters are rarely joined, unlike Humanistic cursive writing. The letter remains curvilinear but has a slope of 10 degrees to the right. The play of thicks, thins, and gradations is also maintained making it a truly elegant form of italic.

The horizontal line that begins the downward stroke in letters such as b, d, h, l, etc. are push strokes for the left-hander. They connect with the downstroke and are to be made in one stroke. Descenders terminate with a push stroke and are to be flat. Flourishes are to be used with restraint and when space and an accented letter are called for. By comparing Chancery Cursive with edged-pen Italic, differences between the two models are readily apparent.

You should become familiar with the plain italic version before attempting the more involved Chancery Cursive.

~: Ludouicus Vicentin. scribebat :~

+ Rome anno domini +

• MDXXII •

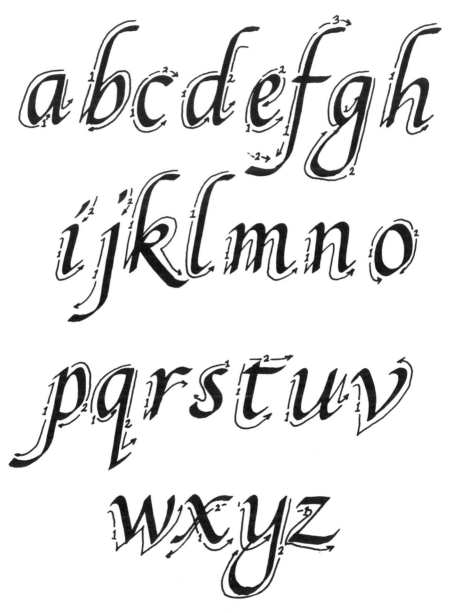

B-3 Nib

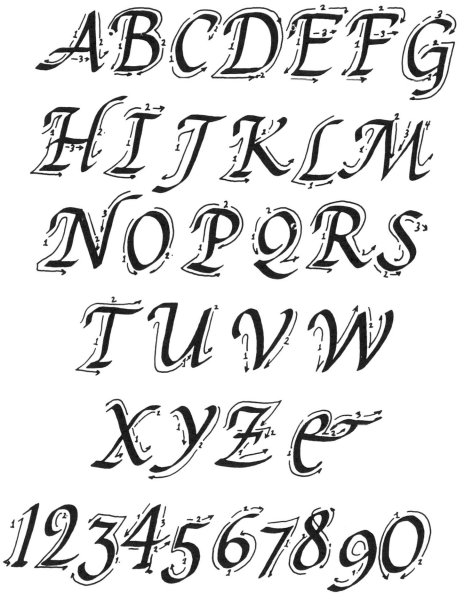

COMPOSITION AND PAGE LAYOUT

Once you are familiar with the letters, words, and lines in the preceding lessons, you must then think of them as ingredients that make up the page. The penman must see the page as a whole before he begins to make his marks on it. The following suggestions will help you unify your work and present it in a balanced manner.

Margins

Margins help to establish the relationship between the writing and background. As mentioned earlier, textual material should not dominate the page. The top margin is the narrowest. Side and bottom margins are usually larger, certainly no narrower than the top in formal letter to page arrangement. The bottom margin can be twice the top margin. A flush left paragraph, where each line begins or continues from the preceding line helps to maintain a neat division between clear, open white space and the active pattern established by the letters. A flush-right ending for all writing lines is difficult to achieve. Careful planning with discriminating use of ligatures and joins and acceptable abbreviations will help to keep the lines from coming too near the gutter of the page.

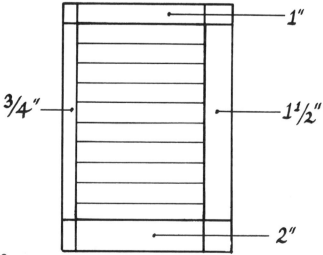

Paragraphs

The usual way to begin each new paragraph is to indent the equivalent of three letter spaces. Skipping of an extra writing line is also acceptable for paragraph indention. Some calligraphers prefer to begin the paragraph by placing the leading word in the outer margin, sometimes with a flourished or decorated letter. If you wish to add a distinct symbol to the written page, use the old paragraph mark ❡ . This gives the page a uniform "edge" and eliminates excessive rivers of white space.

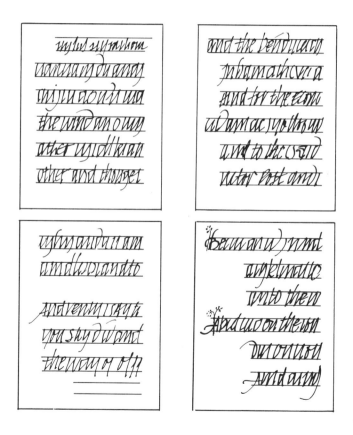

Line Spacing as a Means of Page Color

By opening up or closing the spaces between each line of writing, the scribe can suggest an open or closed look to the overall pattern of letters on the page. The "color" of the page can be improved by a judicious use of correct letter size to correct guideline; i.e., do not, especially in Italic, exceed or choke the required white space by making letters smaller or larger than the given nib size. Common sense for order, both visual and felt, should prevail here. Visual equilibrium escapes rules and hardline definitions.

Learning to write well with the left hand is more than the purchase of an oblique nib, it requires a way of sitting, seeing and doing. This can be developed by combining several resources within reach of anyone who wants to

Captions, Titles, and Headlines

Large letters are best used when, by virtue of surrounding space or a change in the size due to the "mass" of the line, the calligrapher wants to call attention to words for titling and other purposes. As with the textual content, legibility is the chief criterion when large letters are employed on the page, poster, card, sign, etc. The addition of colored ink such as vermillion, blue, or deep green also makes the word or line stand apart from surrounding copy.

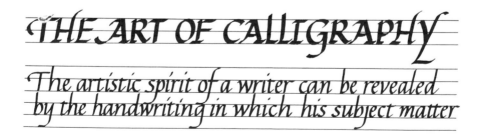

THE ART OF CALLIGRAPHY

The artistic spirit of a writer can be revealed
by the handwriting in which his subject matter

Double Page or Manuscript Layout

A double page (conjugate) layout can be composed according to traditional canons of page space and contents or experimental arrangements may be tried.

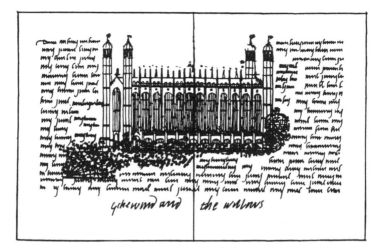

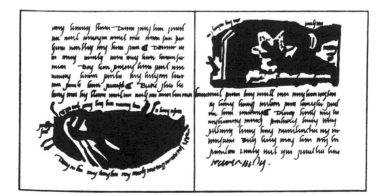

EXPERIMENTAL AND FREE CALLIGRAPHY

I am not disposed to using calligraphy solely for formal purposes. Free, unabashed uses of letters, words, ligatures, and curved lines of writing can make for powerful visual effects. Know beforehand what you want to be legible and what liberties your work may have for expressive purposes. Here, the left-handed calligrapher can open up his lettering technique and enjoy other applications of letters in illustrative or symbolic ways. These examples show what I mean.

EXAMPLES OF STYLE, USE, AND FORM

The examples pictured on these pages show that calligraphic lettering need not always be stiff and formal. Well organized placement of words, large letters used in contrast with small letters, experimental and traditional letters juxtaposed, and the repetitious use of certain letters because of their attractive qualities or just because they "feel good to make" are justifiable reasons to sometimes just "fool around" with the pen. Lettering to music, the sound of a calliope, or the soothing whisper of fluttering leaves can make your endeavors more creative and lift the art of fine writing onto a higher plane. It is at this point that letter, style, and mood give calligraphy the distinct look of thoughtful expression, all the more so when your letters are well made.

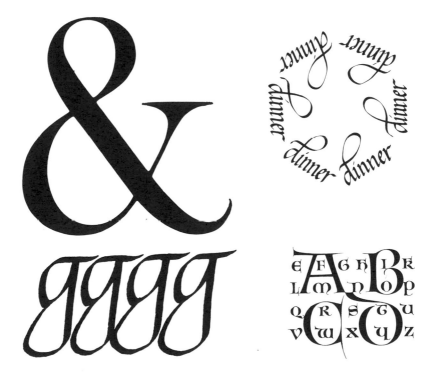

BIBLIOGRAPHY

Fairbank, Alfred and Wolpe, Berthold. **RENAISSANCE HANDWRITING.** New York: World Publishing Company, 1960.

Hewitt, Graily. **LETTERING.** New York: Pentalic Corporation, 1977.

Johnston, Edward. **FORMAL PENMANSHIP AND OTHER PAPERS.** Edited by Heather Child. London: Lund Humphries, 1971.

Johnston, Edward. **WRITING & ILLUMINATING & LETTERING.** London: Pitman, 1973.

THE JOURNAL OF THE SOCIETY OF ITALIC HANDWRITING. London: (All issues are filled with valuable information.)

Kaech, Walter. **RHYTHM AND PROPORTION IN LETTERING.** Germany: Walter-Verlag, 1956.

Meyer, Hs. Ed. **THE DEVELOPMENT OF WRITING.** Switzerland: Graphis Press, 1977.

INDEX

Aldine Press, The, 30
alphabet, *see* letters
angle, 34, 36
arrangement, 30–33
Arrighi, 15

backslope, 26
Baskerville, John, 30
Bodoni, Giambattista, 30
boustrophedon (ox-
 turning), 9

calligraphy, definition, 9
captions, 58
Carolingian script, 13, 14,
 15
Chancery Cursive script, 15
 models of, 52–55
children, teaching of, 23
composition, 56–59
cursive writing, positions
 for, 24–27

desk slant, 20
double page layout, 59

form, 34, 36–37
Foundation hand, models
 of, 44–47

Gothic script, 14–15
Greek alphabet, 11
guidelines, letter formation,
 29
guide sheet, 19
Gutenberg, Johann, 30

Half-Uncial (Irish), 13
hand position, 21–22
headlines, 58
Higgins inks, 19
Higgins Speedball pen and
 nib, 16

Humanistic Cursive script,
 15
Humanists (Italian), 14, 15

ink, recommended, 16,
 18–19
ink flow, pen position, 22
Irish Half-Uncial, 13
Italian Humanists, 14, 15
Italic hand, models of, 48–51

Johnston, Edward, 34, 44

left-handedness
 attitude change, 8
 education, 6–7
letters
 history of, 11–15
 parts of, 28–29
 spacing of, 31
lighting, 19
lines, spacing of, 32–33, 58
Lucas, 15

manuscript, layout, 59
margins, layout, 56
materials, 17–19
Merovingian script, 13
movement, 24

Osmiroid line, 16
ox-turning (boustro-
 phedon), 9

page layout and spacing,
 33, 56–59
Palatino, 15
paper, selection of, 17–18
paragraphs, layout, 57
Parker inks, 18
Pelikan inks, 16, 18, 19

pen and nib
 holding of, 21–22
 left-handedness, 9–10
 positioning of, 22–23, 24, 25
 recommended, 16
 weight, 35
Platignum line, 16
posture, 19
printing press, 15

relaxation, 38
Roman alphabet, 11
Roman Square Capitals, 11
Roman Uncials, 12
Rustic Capitals, 12

slip sheet, 39
spacing, 30–33
Square Capital, 11
Stephens ink, 18

Strathmore and Crane papers, 18

Tagliente, 15
Textura, 14
titles, 58
tone, 30
tools, 16–17

Uncial hand, models of, 40–43
Uncials (Roman), 12

Visigothic writing, 13

weight, 34, 35
words, spacing, 32
writing, primary conditions of, 34–37

Zellerbach Thor Onionskin paper, 18